100 SIMPLE TEACHING METHODS

DR DHEERAJ MEHROTRA

Copyright © Dr Dheeraj Mehrotra
All Rights Reserved.

ISBN 978-1-63832-387-7

This book has been published with all efforts taken to make the material error-free after the consent of the author. However, the author and the publisher do not assume and hereby disclaim any liability to any party for any loss, damage, or disruption caused by errors or omissions, whether such errors or omissions result from negligence, accident, or any other cause.

While every effort has been made to avoid any mistake or omission, this publication is being sold on the condition and understanding that neither the author nor the publishers or printers would be liable in any manner to any person by reason of any mistake or omission in this publication or for any action taken or omitted to be taken or advice rendered or accepted on the basis of this work. For any defect in printing or binding the publishers will be liable only to replace the defective copy by another copy of this work then available.

Contents

Preface	v
1. Teaching Methods	1
About The Author	51
Books By The Same Author	53

Preface

100 Simple Teaching Methods is a requisite towards making a difference in the Teaching Learning Attributes towards Success at alarge.

The book, features towards Managing Distractions Within Classrooms and favours the learning as a part of Kaizen approach towards continuous development in particular. The concept deals significantly towards making a difference towards literacy as a science as well as an art and which can be excelled using the power of intelligence with practice.

A priority on cards for educators!

Best & Cheers!

Dheeraj Mehrotra

www.authordheerajmehrotra.com
tqmhead@aol.com

I
Teaching Methods

Identifying the Classroom Distractions is a priority for the New Age Learning. As Educators, we need to explore the contest of learning with exception.

The concern comes to our minds, why use a teaching strategy?

Well, It is more like an Instructional Method that a teacher adopts to meet a learning objective.

It also aids a teacher to create the right learning environment.

Well, for sure, the teaching methods foster and improve students learning journey. They are important for students to make learning more conceptual and contextual.

For a student's friendly classroom, a teaching strategy need not necessarily be very fancy, it can be simple and engaging and less time consuming.

In order to plan the teaching strategies, teachers need to consider effectiveness and active participation by the students.

As an educator, it is so very necessary to prepare and set clear and fair expectations that have a positive attitude, be mindful and use a teaching strategy which is inquiry driven, creative and innovative.

Assure any of your teaching strategies should not be boring. We need to consider the lack of focus among the kids as a priority.

Some of the Teaching Methods feature as follows:

1. Lecturing

Lecturing can mean an instructional talk or it can take the form of a stern, one-sided talk. It is in part through engaging students in interaction, using questions and answers, that some of the limitations of lectures can be overcome. The lecture has to be Lively, Educative, Creative, Thought provoking, Understanding, Relevant and Enjoyable.

2. Circle Time Activities

A Circle time, also called group time, refers to any time that a group of people are sitting together for an activity involving everyone. Circle time is usually light and fun and has the goal of getting children ready for learning. Consider the 3 basic questions of Why, What and How. Why.

3. Simulation Method

The system of activating classrooms via Simulations refer as instructional scenarios where the learner is placed in a "world" defined by the teacher. They represent a reality within which students interact. The teacher controls the parameters of this "Engagement" and uses it to achieve the desired instructional results.

4. Modelling Method

The process of Modelling during teaching is an instructional strategy in which the teacher demonstrates a new concept or approach to learning and students learn by observing. Whenever a teacher demonstrates a concept for

a student, that teacher is modelling. It activates engagement in real sense.

5. Online Learning Tools

These are the Most Popular Digital Education Tools For Teachers And Learners. The most common ones include, Edmodo which is an educational tool that connects teachers and students, and is assimilated into a social network. Google Classrooms, Kahoot are other commonly used platforms.

6. Game Simulation

As one of the innovative ways of teaching, the use of simulation games implies that the teacher values the unique needs of individual students. During this process, the learning is an active process rather than a passive one. It encapsulates the importance of students' examining their values and the values of others in particular.

7. Collaborative Problem Solving

The very collaborative problem solving acts as "the capacity of an individual to effectively engage in a process whereby two or more agents attempt to solve a problem by sharing the understanding and effort required to come to a solution and pooling their knowledge and skills in totality. It activates learning by doing as hands on.

8. Discussion Groups

The Discussion method of teaching is a group activity which involves the teacher and the student to define the problem and derive its solution. It is a constructive process which involves listening, thinking as well as deriving conversations skills on priority.

9. Peer Instruction

Peer teaching involves one or more students teaching other students in a particular subject area and builds on the belief that "to teach is to learn twice" (Whitman, 1998)." For students, peer learning can lead to improved attitudes and a more personalized, engaging, and collaborative learning experience, all of which can lead to higher achievement. For peer teachers, the experience can deepen their

understanding of the subject and impart confidence.

10. Active Learning

Active learning is an approach to instruction that involves actively engaging students with the course material through discussions, problem solving, case studies, role plays and other methods. The process is towards giving students a time limit to complete the task. The process identifies to Stop the activity and debrief. Call on a few students, or groups of students, to share their thoughts and tie them in to the next steps of your lecture.

11. Project Based Learning

Project Based Learning is a teaching method in which students gain knowledge and skills by working for an extended period of time to investigate and respond to an authentic, engaging, and complex question, problem, or challenge in particular. Project-based teachers make sure that students understand what the learning goals are and why they matter towards catching them young and innocent.

12. Unit Tests

Unit tests are conducted in the school to evaluate the summative assessment of teaching-learning process. The main aim of unit test is to isolate each unit of the system to identify, analyse and fix the defects. Test is different from assessment and evaluation in the following manner towards excellence.

13. Assignments

The Assignment method is the most common method of teaching in schools, particularly in teaching of Science. It is a technique which can be usually used in teaching and learning process. It is an instructional technique which comprises of the guided information, self learning, writing skills and report preparation among the students. It also includes the simple home work assignments as one of the common methods of learning and evaluation.

14. Classroom Quizzing and Brain Gym:

Ask questions and make their brain work brighter. Example: Ask them to make number 9 using their thumb all together. Ask them to

Write their first name in ENGLISH using their index finger in the air.

15. Remedial Teaching

Identify weak students and engage them through peer learning. Involve them through partners as 12.00 O Clock Partner or other time frames.

16. Presentations

Engage them through the presentation skills via Technology.

17. Zoom In

Here let the students observe gradual portions of an image and ask them to write and engage in writing. Ask them what new things they see. How does it change their thinking. Repeat the reveal and questioning until the whole image is revealed.

18. Chalk Talk

Using the Chalk Talk Strategy to engage them via home work analysis. The chalk talk method is a good way to ignite the shy students. It engages the learners, promotes independent thinking and allows them to have an equal say. Here the teacher tells the students to analyse their thought analysis. The students rotate as a team via different prompts. The output is shared in public.

19. Work Books & Step Inside Routine

It gives option to students to answer questions using Step Inside virtually. You let them step inside the character of the individuals. It is like stepping inside the situation in particular. Good for English, History, exploring historical events from a particular perspective. Example Thinking or wondering about a soldier's perspective.

20. Posters and Reading Conference

Showcase the Posters and ask the children to read and interact. This goes via interactions randomly with the peers and the teachers. It integrates Visual Literacy, like I see I wonder.

21. Self-Learning Tools

This is a live example of using tools of learning as a practical approach. Some of the online tools include:

Google Digital Garage, LinkedIn Learning, Coursera, Khan Academy, edX and Academic Earth.

22. Competitions

This includes the various formats like Debates/ Interactions/ Recitation/ Writing/ Fashion Shows/ Speech Contest/ Case Study Presentations.

23. Object Based Learning

Object based learning is a form of active learning. It is a student-cantered learning approach that uses objects to create a more profound learning experience. is an educational method that involves actively using authentic or replica material objects. These objects can include artworks, artifacts, archival materials,

or digital representations of unique objects.

24. Class Summary

The Class Summary integrates learning as a priority. Here to make it effective, the students must first practice the skills of identifying and describing the main topic or activity in a class and giving some coherent, sequenced details.

25. Club Activities

This leads to bodily awareness, independent thinking, problem solving and reasoning, positive self image, talent management and collaboration & team work. The other activities include, co-curricular activities such as public speaking, debate and dramatics, creative writing, eco-club, quizzing, astronomy, dance, photography, philately, trekking, film appreciation and even cookery.

26. Adaptive Teaching

Adaptive teaching as an educational method is an approach aimed at achieving a common instructional goal with learners whose

individual differences, such as prior achievement, aptitude, or learning styles differ. It assists in providing a personalized learning, aiming at providing efficient, effective, and customized learning paths to the learners. It also helps the teachers to engage each student. It is a student data-driven approach to adjust the path and pace of learning, enabling the delivery of personalized learning at scale in totality.

27. Cross Over Learning

The concept of crossover learning refers to a comprehensive understanding of learning that bridges formal and informal learning settings towards teaching excellence. It is one of the techniques used for providing personalized learning and aims towards providing an efficient, effective, and customized learning paths to engage each student.

28. Case Study

The case study methodology incorporates learning through engaging the students in discussion of specific scenarios that represent the real-world examples, like for example, Distractions Within Classrooms. This method is learner-cantered with intense interaction

between participants, as brainstorming. This further makes them develop skills, build their knowledge and work together as a group to examine the case.

29. Self-Learning

Using Google Earth Educational Tools. This helps visualizing the abstract concepts across a global canvas, allowing students to connect what they learn inside to what they experience in their daily lives, community, and to the larger world. Google Earth's creation tools allow you to create your own projects.

30. Team Projects

This may include, Create a poster, Make a PowerPoint presentation, Design a model, Make a shoebox diorama, Use a 3-panel display board, Make a timeline and Create a board game incorporating key elements, write a poem among others.

31. Research Projects

Research-based teaching means that students carry out research in their courses independently and with an open outcome. This methodology of teaching and learning focuses on the joint acquisition of new skills by lecturers and students. This infact requires the teachers to reflect on their role as teachers and learners.

32. Gesturing

This form of teaching integrates the learner's gestures which in process allows indexing of moments of conceptual instability. The teachers during this process make use of those gestures to gain access into a student's thinking. During the very process, the learners discover novel ideas from the gestures produced during a lesson.

33. Instructional Videos

This is a very common methodology to integrate the showcase of learning using videos. The instructions electronically in the form of videos guide the students to follow a specific path and learning is depicted during the process.

34. Social Media

The ultimate use of social media in teaching assists the students with the ability to get more useful information and makes them connected with learning groups and other educational platforms online. It provides the students an opportunity to share their queries, concerns and comments that make education convenient. These tools allow the students and institutions to explore the multiple opportunities to improve learning methods.

35. Humour

Humour in classroom explores the inception of Teaching styles that have changed significantly over the years. It allows the switch from the traditional way that education was delivered was through recitation and memorisation techniques, whereas the modern way of doing things involves interactive methods with humour as a priority now for sure with the march of time and tide as a reality in practice for schools and teachers need to dwell as a hobby for now. The inception is eyed and segmented towards the participative nature of students within classrooms to get the connect and make learning as a priority for both the teacher and the learner in momentum to share the cause of

learning making the best for all.

36. Panel Discussion

During this process of teaching, the process is initiated through observation and listening. In a Panel Discussion, a designated or an invited group of students act as a panel, and the remaining class members act as the audience. The panel further discusses the selected questions and topics in particular. A panel leader is chosen and he/she summarizes the panel discussion and opens discussion to the audience. A question and answer session follows the process for clarity collaboration.

37. Modelling

Modelling is an instructional strategy in which the teacher demonstrates a new concept or an approach to make learning a priority with the preface of teaching excellence and WOW spectrum towards the taste and requirements of the learners. The students during this phase actually enjoy the learning through observation. The learning is done by observing. Whenever a teacher demonstrates a concept for a student, that teacher is modelling as a measure.

38. Discovery Method

The Discovery Learning Method is mandated through the "Guided Discovery" format which refers to a teaching and learning environment where students are actively participating in discovering knowledge by exploring options through working and exploring ideas. It is a constructivist theory and is based on the idea that students construct their own understanding and knowledge of the world through experiencing things and reflecting on those experiences. It is assisted through the inquiry-based instruction and is considered a constructivist based approach to education.

39. Demonstration Method

As the word says, demonstration, the module covers showcasing with explanation in particular. It is used to communicate an idea with the assistance of visuals like flip charts, posters, power point, and other online or offline tools. A demonstration is the process of teaching someone how to make or do something in a step-by-step process. It is good for science subjects.

40. Role Playing Method

Role-play is a technique that allows students to explore realistic situations by interacting with other people in an organised manner towards developing real life skills and experiencing through an environment of choice and chance. It provides an additional learning delight for the students and they can very well understand the scenario being discussed during the process.

41. Oral Questions

This methodology allows the teacher to engage the students via assignments orally. It initiates and involves the teacher, where probing is conducted among the students. Here the questions are floated to think about what they know regarding a topic and in verbal format

they respond. The Questions typically allow the teacher to keep a point of discussion focused on the intended objective and the learning objective through involvement of all the students at length.

42. Questioning Method

This is an add on method to the Oral Questions, and may include the written assignments as well. The objective is towards engaging the students via connect and assignments.

43. Discussion Method

Here we follow the collaborative exchange of ideas among the students for the purpose of igniting students thinking, learning, problem solving, understanding and decision making abilities.44. Problem Based Learning

45. Assignments

This include all types of work assignments, routine jobs, class tests, home work and online reflections.

46. Make free and open source technologies available to teachers and students

The objective is towards specific connect via as per the directions from the UNESCO, Open educational resources and open access digital tools must be supported. Education cannot thrive with ready-made content built outside of the pedagogical space and outside of human relationships between teachers and students. Nor can education be dependent on digital platforms controlled by private companies.

47. Cross Over Learning

The crossover learning format entirely refers to a comprehensive understanding of learning that bridges formal and informal learning settings within a classroom. The learning through this medium can be enriched by experiences from everyday life; informal learning can be deepened by adding questions and knowledge from the classroom. The objective for this format is towards combining the strengths of both formal and informal learning environments, and aims to provide students with the best of both in particular. As per the boardteachers.com, an effective method for crossover learning involves teachers

proposing a question or problem in the classroom to be solved in museum visits or field trips. Children can learn by collecting photos, taking down notes, or asking other people for their own thoughts. They then present what they learned back in the classroom to further illuminate the given problem.

48. Dramatic Method

It is more like drama in teaching or dramatics in teaching. This at random allows students to explore the curriculum using several of Gardner's multiple intelligences. Here the kids are fully involved in learning with drama as a practice. They are immersed into the subject through the activities and do role plays of characters on the subject of learning. The process activates at length, the development of their skills and particularly, their bodies, minds, and emotions yielding in creativity and innovation as a common practice.

49. Pen Pals

A coined word of yester years, has an interpreted meaning today. Teachers and educators around the world share their experience with global project based learning through PenPal

platforms. One of the schools, practicing this says: We set the children up with their own email addresses, and put these under one central email alias. This allowed the teachers to screen each email exchange to make sure it was appropriate, and then prepare spelling lists and topic word banks based on the exchanges. Because the messages were now arriving within seconds of hitting "send," we moved to weekly exchanges. This allowed our students to breeze through the usual "getting to know you" questions and move on to topics that really allowed for meaningful cultural exchanges.

50. Audio Tutorial Lessons

Also known as PODCASTING in novel sense, the format is widely used in schools. The audio-tutorial instruction is the most complete and most well-documented method of auditory presentation among teachers.

51. Mobile Applications

Mobile apps help in systematic learning in a big way. The best part is the Mobile learning (m-learning) is education via the Internet with the help of personal mobile devices. This is encompassed with BYOD- Bring Your Own

Device format in schools where devices like tablets and smartphones assist learning to a better level. It helps to obtain learning materials through mobile apps, social interactions and online educational hubs.

52. Flowcharts

This is a diagrammatic way of teaching where each activity is represented through a symbol. These are joined through the direction arrows and are connected through lines.

53. Brain Storming

This is an act of idea generation. This as an activity encourages students to focus on a topic and contribute to the free flow of ideas. Ideally, it is initiated by the teacher as a facilitator who may begin a brainstorming session by posing a question or a problem, or by introducing a topic. Students then in process one by one, express possible answers, relevant words and ideas.

54. Simulation Games

The use of simulation games within classrooms, implies that the teacher values the extraordinary needs of individual students. It signifies that learning is an active process and hence has to equip with innovation and creativity.

55. Psychomotor Development Methods

Psychomotor learning is demonstrated by physical skills such as movement, coordination, manipulation of learning traits among students. It delivers organized patterns of muscular activities guided by signals from the environment.

56. Inquiry Method

Inquiry-based learning is an approach to learning that encapsulates the student's role in the learning process. Rather than the teacher telling students what they need to know, students are encouraged to explore the material, ask questions, and share ideas instead.

57. Ensure scientific literacy within the curriculum.

As guided and reflected by UNESCO, this is the right time for deep reflection on curriculum, particularly as we struggle against the denial of scientific knowledge and actively fight misinformation. Teachers can help and guide students using various topics via scientific literacy.

58. Webinars

A webinar is an interface over the Internet. A much talked and explored during the CORONA times globally. The webinar allows interaction between the students and the professors online. When used in a classroom as a medium of teaching, it helps remove the scepticisms from the minds of the students who are shy to raise their hands and ask questions in a classroom full of students. A very effective tool in particular.

59. Process Approach Method

The process approach is a method of thinking, applying to understand and plan the sequence and interactions of processes in the system. Teaching here is integrated through a processes and the interactions of these processes as part of

the teaching and learning system in a classroom scenario.

60. Hands On

Hands-on learning is a teaching pattern of imparting education in which children learn by doing by themselves. Instead of simply listening to a teacher on the specified subject, the student engages with the subject matter to solve a problem or create something via hands on experience via engagement and team work in particular.

61. Seminars

A seminar is an opportunity to learn or explore learning via interactions. Particularly in academics, a seminar may have several purposes, one such as a lecture, where the participants engage in the discussion of an academic subject for the aim of gaining a better insight into the subject. For a normal classroom scenario, it works as an option for learning with pleasure.

62. Chalk and Talk

A Chalk Talk is a much preferred and a silent activity that provides all students the opportunity to reflect on what they know, and then share their thinking and wonderings while connecting to the thoughts of their classmates. "Chalk & Talk" is a formal method of teaching with a blackboard and the teacher's voice as its focal point. This method is used in classrooms across the world. Despite the name, there is no chalk involved with the advent of technology, only paper and pencils, markers or digital devices in particular.

63. Laboratory

For sure, the School labs are a great place for students which help them enhance their learning by understanding the theoretical concepts of science which are taught in classrooms. The set up of the student friendly has to be encapsulated Well-designed laboratories not only make science experiments fun but also help students in achieving good academic results. It salutes the framework of learning through demonstrations and hands on learning.

64. Content Analysis

Content analysis is a research method which allows the qualitative data collected in research to be analysed systematically and reliably so that generalizations can be made from them in relation to the categories of interest to the researcher. It is one of the activities of the ACTIVE RESEARCH by educators and the research findings help deliver learning as a priority for schools.

65. Reciprocal Teaching

Reciprocal teaching refers to an instructional activity in which students become the teacher in small group reading sessions. Reciprocal teaching refers to a classroom activity where students are shown strategies to better understand a reading. As one of the periodic models of teaching, RT helps students learn to guide group discussions using four strategies: summarizing, question generating, clarifying, and predicting in particular.

66. Assignment Method

With the help of the Assignment Method, an evaluation based learning is possible. Using this process of assignment method, the teacher

delivers an assignment with clear instructions, milestones, objectives and grading criteria based on an outcome that students need to achieve as an activity scheduled over a phase of time. The teacher accordingly monitors and further delivers the feedback to students as they solve the assignment and shares the feedback towards improvement as an outcome.

67. Micro Teaching

It is a part of teacher training, but for sure helps students to learn a lot. Microteaching can also defined as a teaching technique especially used in teachers' pre-service education to train them systematically by allowing them to experiment main teacher behaviors in the real life scenario. It more or less, helps as a revision module, on the go which enables teacher trainees to practice a skill by teaching a short lesson to a small number of pupils. Usually a micro lesson of 5 to 10 minutes is taught to four or five fellow students.

68. Mastery Learning

Mastery learning also known as competency based teaching is a set of group-based, individualized, teaching and learning

strategies based on the preface that students will achieve a high level of understanding in a given domain if they are given enough time. It ensures that the students obtain mastery in a given topic before moving on to the next unit. The objective is towards gaining high levels of achievement through active instructions, time and perseverance.

69. Direct Instructions

Direct instruction is a teacher-directed teaching method. This means that the teacher stands in front of a classroom, and presents the information. The teachers give explicit, guided instructions to the students. To make it simple and effective, the term direct instruction refers to instructional approaches that are structured, sequenced, and led by teachers, and/or the presentation of academic content to students by teachers, such as in a lecture or demonstration within the classrooms over a specified interval.

70. Flipped Classrooms

A flipped classroom is a pattern of mixed learning where students are introduced to content at home and practice working through it at school. It adheres to the reverse of the more

common practice of the traditional format of introducing new content at school, then assigning homework to the students. It was pioneered by two high school teachers in Colorado named Jonathan Bergmann and Aaron Sams.

71. Kinaesthetic Learning

Kinesthetic-tactile techniques are used in combination with visual and/or auditory study techniques, producing multi-sensory learning. These activities help towards enrichment of learning into long-term memory by turning a lesson into a physical experience for the students. Kinaesthetic learning happens when we have a hands-on experience. An example of a kinaesthetic learning experience is when a child learns to use a swing or to ride a bike. The students in process can read instructions or even look forward to listen to instructions, but deep learning occurs via the process of doing as a hands on learning approach in particular.

72. Differentiated Instruction

Differentiating instruction explores the reflection of the same material to all students using a variety of instructional strategies. In

addition, the teacher would explore delivering, lessons at varying levels of difficulty based on the ability of each student. Differentiated instruction is an approach to teaching where the teachers actively plan for students' differences so that they can explore learning the best way possible. For teachers and administrators, it is like "adapting content, process, or product" according to a specific student's "readiness, interest, and learning profile." This certianly leads to joyful learning in particular.

73. Expeditionary Learning

During the process of Expeditionary Learning the students learn by conducting "learning expeditions" rather than by sitting in a classroom being taught one subject at a time. "Through the EL model students are provided with an on-par learning environment both physically and with the curriculum that gives them the chance to explore something uncommon and creative. Expeditionary learning allows children to take education into their own hands, literally, the Expeditionary Learning primarily involves "Project Based Learning." in totality.

74. Personalized Learning

Personalized learning is an educational approach that aims to customize learning for each student's strengths, needs, skills and interests. Each student gets a learning plan that's based on what he or she knows and how the learning is achieved at its best. The objective hers is to dwell into designing and structuring the learning to meet the needs of every student. It defines an educational approach that aims to customize learning for each student's strengths, needs, skills and interests. Each student gets a learning plan that's based on what he knows and how he learns best.

75. Game Based Learning

As the name suggests, gaming or joyful engagement is the priority. The core concept behind game-based learning is teaching through repetition, failure and the accomplishment of goals. Video games are built on this principle. It is characterized by fantasy elements and it uses competitive exercises in order to motivate students to learn better. In addition, Game-based learning refers to the borrowing of certain gaming principles and applying them to real-life settings to engage users, particularly the students.

76. Conducting a Discussion

Discussion is a style that challenges students to be responsible for their own education. Students are required to sit around a circle and are tasked to find new information together which may include a talk, wait for answers, and ultimately think for themselves. An orderly format of discussion is also known as Brainstorming. This is an ideal way for variety of forums for open-ended, collaborative exchange of ideas among a teacher and students towards furthering students thinking, learning, problem solving, understanding and innovating towards excellence.

77. Forums

The forums represent a community or a group for learning. It is defined as a space for the discussion, creation and implementation of innovative and creative learning methodologies and strategic partnerships between the students and the teacher within a classroom. It involves the process of group discussion and incorporates, Class discussion. The objective is towards conduction an interactive model through asking an open ended question on a regular basis. The teacher further observes and evaluates wheter the student have contributed towards making further progress towards engagement.

78. Bulletin Boards

Bulletin boards are a powerful learning tool for classrooms ranging from preschool to high school and beyond. The Bulletin boards reflect a class or school's identity in a big way. It represents the mission, the vision of the school, the objective of the class or the session to be covered when used by the teacher. As a surface intended for the posting of public messages it serves as a ready reckoner for the students.

79. Reading Assignments

The reading assignment is a format of teaching or evaluating a learning scenario where the reading of a passage is assigned by the teacher. The lesson is given a task assigned for individual study. These reading assessments and assignments help children assess what they do understand about a text and even explores further learning.

80. Crossword Puzzles

Crossword Puzzles motivate students towards learning with joy and creativity. It motivates the students on the go and helps students to extend their vocabulary knowledge. As a live example, forwarded through the News Papers and Magazines, the Language classes can well

relate to finding words based on clues, students can playfully learn new vocabulary in their native language or a foreign language. When teaching foreign languages, you could do the same and describeAnother fun way to use jigsaw puzzles in geography is to teach your students about vegetation l the foreign words in the foreign language accordingly. The science teachers can use crosswords as well to teach terminology.

81. Jigsaw puzzle maps

These are the ancient educational tool that was intended to teach students to put together maps about their country or the world. Further in academics the teachers use jigsaw puzzles in language lessons to let students practice their speaking skills. Teachers often introduce themselves by telling their name, hobbies, if they have kids or not, what they like or don't like and so on. Try to switch things around with a jigsaw activity.

82. Mind Maps

A mind map is a learning tool that helps students to create and share visual representations of things. For example a chapter

on Climate, can have a depiction on mind map accordingly. It is a description of what is taught during lectures, notes, and normal classroom procedure. In conception towards learning, a mind map is a type of diagram that visually links a central subject or concept to related concepts, ideas, words, items, or tasks. The implementation of Mind Maps in teaching has grown over the time towards harnessing the creativity and implementation towards excellence in teaching and learning process. A mind mapping is done for what has been covered in the class to engage students, encourage creativity and teaching how to learn rather simply memorizing content. These are integrated into emerging teaching techniques such as the Flipped Classroom and Design Thinking as a productive format of learning with delight within classrooms.

83. Quality Circles

A QC or a Quality Circle is a group of 5 to 15 members, ideally 8, who sit together in the form of a circle and brainstorm over issues related to real life problems. They identify the causes of the problem and finally develop the strategies to solve the problem. Finally the strategies are implemented towards improvement. This process is a much talked about process towards gaining problem solving skills and creativity on

the go. A concept derived from Japan, it follows the culture of Kaizen, which means Change for better.

84. PDCA Charts

Also known as Plan Do Check and Act (PDCA) Charts. It involves systematically testing possible solutions, assessing the results, and implementing the ones that have shown to work. The PDCA/PDSA cycle is a continuous loop of planning, doing, checking (or studying), and acting. The PDSA cycle is a systematic series of steps for gaining valuable learning and knowledge for the continuous improvement of a topic or process. In a classroom situation, PDCA Charts provide a simple and effective approach for solving problems and managing change.

85. DMAIC Approach

Define, Measure, Analyse, Inspect and Control forms a new way of understanding a topic or a situation. It is actually based on sustainable education development and the concepts of DMAIC (Define, Measure, Analyze, Improve, Control)-a six sigma process improvement methodology integrates as a quality strategy towards the improvement of process and

learning. The DMAIC template keeps students on track towards engaged classrooms and effective management of learning. It focuses on identifying problems and using a systematic, scientific approach towards its problem solving.

86. Flash Cards

Flash cards are a really handy resource to have and can be useful at every stage of the class. They are a great way to present, practise and recycle vocabulary and when students become familiar with the activities used in class, they can be given out to early-finishers to use in small groups. Flash cards are not new to teaching and learning. Teachers have been using flash cards, or flashcards, or flip cards of one kind or another to teach vocabulary and other concepts for a very long time. A new dimenstion based learning is also on cards with the introduction of digital flash cards as a great learning tool.

87. Interviews

The interviewing process in a classroom scenario provides a unique method for evaluating what the students know and need to know. It works on observatory evidences

through interactions and is a modelled way to gain competency over a subject by the students and the teachers in particular. It functions as an interactive model of communication and information sharing among the students and teachers.

88. Surveys

It is one of the data capture formats of learning and exploring knowledge. A part of the experiential learning framework, it occupies the interest of the students in a big way. The Student surveys lead an important learning and help towards improving teaching effectiveness via feedback. A student survey allows them to voice the common issues, needs, and desires. It also helps in providing a feedback on teacher's traits and improvement with the march of time.

89. Reading Aloud

A very common primary and pre-primary teacher's activity of yester years, is too common in schools. At times relate and refer to interesting paging of learning in higher grades. From the students point of view, it improves their information processing skills, vocabulary,

and comprehension. The process in a way helps students become proficient readers and thinkers. Reading aloud is more than fun – it's an effective teaching strategy and certainly, it facilitates teachers to expose students to exceptional literature.

90. Exhibition

Exhibition is a process to test the application of whatever has been taught or learned. The students during this activity learn to apply the knowledge and information collected through various sources. The teacher accordingly acts like a facilitator and undergoes the opportunity to test the students what and how much they have learned. What we include here are projects, presentations and products through which students "exhibit" what they have learned. Technology plays a vital role here to showcase the work in the audio, video and text combination as a demonstration of the work. This explores the learning objectives and the outcomes as expected. An exhibition is typically both a learning experience in addition to being an evaluating academic progress and achievement for the students at large.

91. Exchange Programme

The exchange programme is a connect or a networked learning over a passage of time. It is a study program in which students pursue education at one of the international institutions for six months to one year. We also have national schools and local schools where we share the learning environment. Various models are being exhibited through technology via webinars and other digital platfroms where the competency is shared and explored. An international exchange program can be an excellent way to broaden the experience and obtain valuable cultural insights with life skills contributing towards building of the overall personality.

92. Interactive Lecture

Interactive Lecture based teaching is a format of instruction where the teachers act like facilitators and involve the students by way of regular interactions. They use technology and hands on for demonstrations to encourage, motivate and engage the learners in process. Here the teacher delivers a well-organized, tightly constructed, and highly polished presentation followed by an interactive Question and Answer session.

93. Film and Video

The Film and video include some of the fascinating ways to educated and entertain students about a particular concept. This way the students are motivated towards understanding the concept the better as it is clubbed by the understanding in process. The understanding is evaluated by the end through discussions and interactions. This indicates a combo of innovative format of visual education aids like video, online spectrum, live, online and even off line which work a lot towards improvement of various skills in particular.

94. Design Thinking

The Design Thinking or DT is a positive mindset approach towards learning through decision making as a priority. It aids towards learning, collaboration, and problem solving. It is a structured framework for identifying causes to a problem as a challenge and helps in gathering information, generating potential solutions through the process of Empathy, Ideation and Prototype. It manipulates the spectrum of Design Thinking in Education through the attribution of Empathy, Challenge, Discovery, and Sharing.

95. Personalised Instruction

It is one of the important forms of learning and teaching. It refers to instruction based learning in which the pace of learning and the instructional approach are optimized for the needs of each learner. As a Learner Centric and Specific format of learning, it fascinates learning towards priority. Learning objectives, instructional approaches, and instructional content (and its sequencing) may all vary based on learner needs.

96. Recitation

A recitation in a general sense is the act of reciting from memory, or a formal reading of verse or other writing before an audience. The definition of a recitation is the telling of details, or the act of saying something that's been memorized out loud, or the thing that is read.

97. Memorization

It defines the means of learning by self. For sure, many students feel like they simply do not have strong memory skills. Fortunately, though, memorizing is not just for an elite group of people born with the right skills—anyone can train and develop their memorizing abilities.

98. Reasoning

This concerns the critical way of learning and exploring the new unknown. Logical reasoning determines if algorithms will work by predicting what happens when the algorithm's steps - and the rules they consist of - are followed. Predictions from each algorithm can be used to compare solutions and decide on the best one.

99. Social-Emotional Learning

Social-emotional learning (SEL) is the process of developing the self-awareness, self-control, and interpersonal skills that are important for school, work, and life success. People with strong social-emotional skills prove out to be better towards coping with daily life challenges and benefit academically, professionally, and

socially. This strategy occupies an emotional connect with the teachers among the students. Targeting the development of these skills can translate into higher academic achievement, among other gains. It includes self management, self awareness, social awareness, relationship skills, creative thinking and decision making skills among others. It works on creating an environment conducive to learning and is promoted through explicit instruction to the students.

100. Instructional scaffolding

Instructional scaffolding is a process through which a teacher provides supports to students in order to enhance learning and assists in the mastery of tasks. Here the instructor does this by systematically building on students' experiences and knowledge during the learning of the new skills.

DR DHEERAJ MEHROTRA

About The Author

Dheeraj Mehrotra, MS, MPhil, Ph.D. (Education Management) honoris causa., a white and a yellow belt in SIX SIGMA, a Certified NLP Business Diploma holder, is an Educational Innovator, Author, with expertise in Six Sigma In Education, Academic Audits, Neuro Linguistic Programming (NLP), Total Quality Management In Education, an Experiential Educator, a CBSE Resource towards School Assessment (SQAA), CCE, JIT, Five S and KAIZEN. He has authored over 40 books on Computer Science for ICSE/ ISC/ CBSE Students, over 10 books of academic interest for the field of education excellence and Six Sigma. A former Principal at De Indian Public School, New Delhi, (INDIA) with an ample teaching experience of over Two Decades, he is a certified Trainer for Quality Circles/ TQM in Education and QCI Standards for School Accreditation/ Six Sigma in Education. He has also been honored with the President of India's National Teacher Award in the year 2006 and the Best Science Teacher State

ABOUT THE AUTHOR

Award (By the Ministry of Science and Technology, State of UP), Innovation in Education for his inception of Six Sigma In Education by Education Watch, New Delhi and Education World- Best Teacher Award, BOLT Learner Teacher Award by Air India, 'Innovation in Education Award 2016' by Higher Education Forum (HEF), Gujarat Chapter, among others. He has developed over 150 FREE EDUCATIONAL MOBILE Apps for the Google Play Store exclusively for Teachers, Students and Parents. This work has been recognized by the LIMCA BOOK OF RECORDS & INDIA BOOK OF RECORDS as the only Indian to draw that feast. Dr. Mehrotra is presently working as an Academic Evangelist in India. He has conducted over 1000 workshops globally on "Excellence In Education" integrated with Total Quality Management and Six Sigma, Technology Integration in Education (TIE), Developing towards being ROCKSTAR TEACHERS, including Cyberspace, Cyber Security, Classroom Management, School Leadership & Management and Innovative teaching within classrooms via Mind Maps, NLP and Experiential Learning in Academics. He is an active TEDx speaker and can be viewed at youtube tedX channel.

He can be visited at www.authordheerajmehrotra.com

BOOKS BY THE SAME AUTHOR

Scan the above QR Code to know more about the books on Education Managementby Dr Dheeraj Mehrotra

www.ingramcontent.com/pod-product-compliance
Lightning Source LLC
Chambersburg PA
CBHW021038180526
45163CB00005B/2182